How To Learn Tattooing

Getting A Tattoo Apprenticeship

GRAHAME DAVID GARLICK

Copyright © 2012 Grahame David Garlick

All rights reserved.

ISBN-13: 978-1503214828
ISBN-10: 1503214826

CONTENTS

1	Introduction	Pg 6
2	Should I Start Tattooing?	Pg 8
3	How Much Will I Earn?	Pg 11
4	What Equipment Will I Need?	Pg 15
5	Does Age Matter?	Pg 18
6	Self-taught Tattooists	Pg 20
7	Paid Apprenticeships	Pg 22
8	Earning Money Whilst Doing Your Apprenticeship	Pg 25
9	Creating A Portfolio	Pg 26
10	Styles Of Artwork	Pg 28
11	Creating A Sketchbook	Pg 30
12	Finding An Apprenticeship	Pg 32
13	Choosing The Right Shop To Learn In	Pg 35
14	You First Day On The Job	Pg 37
15	What Are A Tattoo Apprentices Duties?	Pg 39
16	How Long Will It Take To Start Tattooing?	Pg 41
17	When Will I Start Making Money?	Pg 43
18	Is Tattooing Hard To Learn?	Pg 45
19	Getting Registered	Pg 47
20	Final Thoughts	Pg 49

1 INTRODUCTION

In this book I will tell you how to stand out from the thousands of other people wanting to make tattooing their career. I will cover everything you need to know from the ground up. Starting with a chapter dedicated to the things you may not have considered about the job right through to how to build an impressive portfolio, how to get an apprenticeship, how much you will earn and how to get registered.

My aim in this book is not just to tell you how to start but to educate you into how the world of tattooing works and give you a behind the scenes view of things.

Another thing I want to mention is that I am an ex-tattooist. Yes, an ex-tattooist. I believe that viewing things from the perspective of an ex-tattooist will work hugely to the advantage of anyone reading this book.

The fact that I am no longer in the industry means that I can give an honest and impartial view on the profession without having to worry about insulting my own line of work. This is important as if you're going to go through the effort of creating a portfolio and spending the time finding an apprenticeship then you need to be sure this is the job for you.

I tattooed for a total of about 6 years and trained one apprentice in that time. So not only have I gone through the apprenticeship process myself, I also trained someone else and had countless people ask me to train them

over the years. Meaning I know how these things work from both points of view and I know what tattooists look for in potential apprentices.

I'm not going to ramble on too much in these chapters just keep them down to the information that you need. My thinking is that a shorter book with more concise information is better than a long book talking about a lot of stuff you don't need to know. Quality over quantity and all that stuff.

2 SHOULD I START TATTOOING?

When I see people giving advice to people who want to start tattooing, this topic is almost always overlooked. For me, this is the most important part of the book. Just to warn you, this chapter may be extremely negative but this is stuff that you need to hear if you're thinking about getting started in tattooing. So if you pay close attention to any chapter, it should be this one.

Firstly I have found that a lot of people look at tattooing as being an extremely "cool" job where you're your own boss and you can earn silly money from it. While it is considered to be a cool job and technically you're your own boss, you almost certainly won't earn as much as you think you will. I will go into exactly how much you can expect to earn and how soon later in the book. Also unless you open your own shop, you will be working for someone and effectively have a boss to answer to.

Most tattooists work on a self-employed, space rent basis with a studio. This is basically where a businessman who usually isn't a tattooist themselves, opens a shop and gets tattooists in to work there. In return for a shop to work in and usually most of the supplies such as inks, needles etc. the tattooists will hand over half of everything they earn (excluding tips) to the shop owner.

These owners, although technically not your boss, will usually act like it. They don't care about if you are a new school specialist for example, if someone walks in the shop wanting a realism back piece they will expect

you to do it. If you don't you will be losing them money and that is something that they will not have. Of course the owners aren't always at the shop, I have sent business to rival shops if I don't think I could do it well and just not told them about it! But you should be aware of this regardless as sometimes you will have no choice but to do tattoos that you don't think you can do well and probably won't enjoy at all.

Also, the owners will often employ managers. These people are 99% of the time non-tattooists who will be telling you what to do and advising clients on their tattoos even though they don't tattoo. Bit of a silly system but there's not much you can do about that. These people are actually in a higher position of power than you, the trained, registered tattooist. I won't lie, this can get extremely irritating.

It's not only the owners and managers but the other tattooists that can be a problem. Tattooists generally tend to have rather inflated egos as a rule of thumb. Obviously this isn't true of every single one, but I have worked with enough tattooists to know that the arrogance levels are much higher than that of the general population. The problem with this is that if you have any disagreement about any small matter such as if you comment on their cleanliness or you suggest a way they could improve their composition for example, this can escalate very quickly indeed. Basically don't tell them they are wrong about anything otherwise you could have a serious argument on your hands.

There is also a lot of dirty work involved in tattooing such as breaking down your station, wiping everything down with a surface disinfectant, cleaning and loading the ultrasonic cleaner before cleaning it again, bagging the tubes, sterilizing tubes in the autoclave, mopping the floor, constantly washing your hands, wiping down the shelves and ink bottles, setting up your work space for the next client, bagging your rinse bottle, bagging your machine, bagging your clip chord, the list goes on. Basically a lot of constant cleaning, every single day. Unless you have been tattooing for years and have an apprentice who will do all of this for you of course.

Another issue for me would definitely be job stability. Seeing as you have no contract with the business owner and are self-employed, you could lose your place at the shop any time. The usual reason for losing your job would be a disagreement with another tattooist at the shop I have found. The problem with this is that you could be in the right and you could be the better tattooist, but if the tattooist you are having the disagreement with earns the shop more money than you do, you will be the one losing your job.

The final problem I found with the job is the clients. You will be spending extended periods of time in very close vicinity to and engaging in conversation with any Tom, Dick and Harry that walks through the door.

The potential issues with this are obvious. Not only could they be an "unsavory" type to say the least, something you may not have considered is personal hygiene. Clients tend to sweat more during tattoos and this is especially problematic with foot tattoos! This may sound funny but believe me, it's a real problem! I have spent many an hour tattooing at full arm's length from my client with a fan blowing full blast in my face.

So, that's the negativity and the warnings out of the way. If you think you can deal with these issues when they come along in order to pursue your dream of becoming a successful tattooist then read on and we will get you started.

3 HOW MUCH WILL I EARN?

As I mentioned in the last chapter, the way most deals work is that you rent the space in a shop. They give you a shop to work in along with the disposable supplies you need such as inks and needles. In return you give them half of everything you earn. This does vary from shop to shop but that's usually the deal.

Half of everything you earn does sound like a lot, but tattooists at the time of writing this book charge about £70 (GBP) an hour on average. £35 an hour is still very good money right? But when you also consider that at the time of writing this book the current income tax rate in the UK is 20% this starts to sound a lot worse than the full £70 an hour a lot of people think tattooists earn. So essentially you're only taking home 40% of the initial £70 you were paid which is £28 an hour. Still good? Unfortunately there are a few other things to consider that make a large impact on your earnings.

In most jobs you work from 9 to 5 and you do this 5 days a week totaling 40 hours. In tattooing you probably won't be working 40 hours even if you decide to work 6 days a week or to work evenings (which a lot of tattooists do).

There is 3 main things that will cut down the amount of hours you are able to work in a week dramatically. Reason number one, and perhaps the most troublesome reason, is that work is extremely hard to come by these days. There is so much competition out there with practically everyone and their

goldfish wanting to become a tattooist at the moment. The last shop I worked in was on the same road as 4 other tattoo studios, that's approximately 10 tattooists working on one road at any given time.

That was a particularly slow shop however with about 1 walk in (a walk in is what tattooists call someone who randomly turns up wanting a tattoo) a week split between two tattooists. This meant we had to have our own client bases to keep us going and our livelihood relied on our existing clients spreading the word to their friends and family.

This is a common problem in tattooing, one girl I worked with had just 2 clients in one particularly bad month. Meaning she earned less than £100 in a whole month.

That being said, if you are exceptionally talented and experienced enough to lay down a solid tattoo, word will spread quickly and you will get a lot of business regardless of walk ins. Or you could get lucky and land a spot in an extremely busy high-street shop in a town center. There is a shop near to where I live right in the middle of the town center, they have about 6 tattooists working every day and are fully booked even though they have some of the worst tattooists in areas working there. So, this work rate issue is dependent on a few factors obviously.

The second reason you won't be working constantly is that you have to design the tattoos before tattooing them. Gone are the days of old, back when hand painted tattoo flash adorned every inch of wall space in the studio. The days when bold, noble sailors would stride in to the shop on shore leave, choose the image from the wall and have the pre-made, one size fits all acetate stencil applied directly to their skin. These days it's far more likely a pretty boy with a bright orange tan and a £80 hair cut will want to discuss his custom bio-mechanical sleeve with you.

This means you will be spending just as much time drawing the tattoos as you will be spending tattooing them. As you are only paid for the time you spend tattooing, this becomes a massive problem potentially halving your earnings again. The only remedy to this problem is to draw in your spare time in the evenings and on the weekends. But this doesn't put your earnings percentage up, just means you will have to work longer hours, so I will take that into consideration in the final calculation. This is getting complicated isn't it? Only one more thing to go though.

The final issue regarding earnings is that you need a break between clients for various reasons. Also breaks during long sessions also for various

reasons. I will also lump fainters, people who throw up or can't handle the pain and cancelations into this category.

In my 6 years of tattooing I have only ever had 2 people throw up during a tattoo and had very few fainters but they are still worth mentioning I think. A far more common issue is people simply not being able to handle the pain and needing to either reschedule or take a lot of breaks to get through it. When you add those people to those who just decide to either cancel last minute or just not tell you at all then you have a bit of a problem on your hands. Of course non-refundable deposits can help a great deal.

The aforementioned breaks between clients are needed because you can only estimate the amount of time a tattoo will take. This means you will need to leave some breathing room to break down your station and set up again but also you will need a rest when regularly tattooing due to the fact that you are hunched over most of the time and you back can begin to get quite painful.

The breaks during sessions are for many reasons but I have found that most people like to have a break every hour to help with the pain, to stretch their legs, have a cigarette etc. These breaks also help with your inevitable back problems and to help keep your concentration levels up.

So, all of that said it's now time to make a total. So let's say competition is pretty stiff like it usually is these days and you're not an exceptionally talented tattooist (not bad just run of the mill) and you're not lucky enough to be located in a walk in hot spot. I would say 50% of the time you will not have clients. So that halves the £70 starting point to £35 an hour.

Then when you do get clients you need to draw the design, lets say that takes you less time than tattooing it but then you may have to redraw it multiple times and make changes, then discuss the coloring with them etc. so I'm going to go with 40% of the time you do have clients so 40% of the £35 leaves us with £21 an hour.

Then the breaks between clients, breaks during sessions, cancelations, fainters, people who throw up, no shows and people who can't take the pain probably knock another 20% of off the actual time spent tattooing after the other two things so that leaves us with £16.80 an hour.

Then of course the shop takes 50% of everything you earn so that leaves us with £8.40 an hour. Then if you're honest enough to declare all of this cash in hand work to the tax man then you are left with £6.72 an hour.

Obviously working 6 days a week or evenings are always a possibility and you may get lucky and be very busy so this is just a rough idea of the harsh reality of things. But it gives you an idea of how that £70 everyone will envy you for earning can very quickly dissipate into something close to minimum wage.

4 WHAT EQUIPMENT WILL I NEED

As I mentioned previously the shop will generally provide everything that is disposable. The tattooists will usually need to have their own machines, clip chord, foot switch, machine maintenance equipment and power supply.

That is all you generally require to own to work in almost any shop. When starting an apprenticeship however you won't need any of this.

Apprentices will start out just watching and taking everything in. Before you even touch a tattoo machine you will first have to prove your worth and learn the inner workings of the studio.

The required equipment can be acquired over the initial part of your apprenticeship. I would suggest getting settled in the shop before buying anything for a few reasons. The main reason is that you may only last a matter of days, weeks or months with your new mentor. If you then can't find another shop you will have a lot of expensive gear and no use for it.

Also the tattooist you are learning from will probably have some suggestions on what machine you should buy or may even give you some equipment as a gift. There is also a possibility that if you move shops after buying a rotary machine on the advice of your old mentor, the new one may only use coil machines. So as I say, just get settled in first and make sure you are happy at the shop and that they like you and want to keep you on indefinitely before spending any money.

Also some power supplies may have certain readouts that your mentor may want you to use as a tuning guide such as the duty cycle for when you are learning the mechanics of tattoo machines. Some tattooists may also want you to learn using a faster cutback liner, where as I personally prefer a liner with a long stroke. The possibilities go on, so it's definitely best to wait.

A personal suggestion however for a great machine that can be used as a long stroke liner, for shading and coloring would be the Micky Sharpz T-dial. Always listen to the person you are learning from though, there are plenty of hybrid machines out there, I only mention this as a suggestion!

A lot of tattooists rather than asking you to buy your own set up will simply let you use theirs for a while. A traditional gift to symbolize the completion of your apprenticeship is a tattoo machine from your mentor so you may not even need to buy one at first if it's a good hybrid. This is wishful thinking though as this isn't commonplace these days.

Personally I wasn't given a machine, I didn't mind as I'm one of those fussy kind of people who prefers to do their own research and buy the best machine to suit my needs rather than just using what I have been given.

Another reason you should hold off on buying a machine is because you don't yet know if you will be lining by "riding the tube" or "riding the needle". These are terms for the two styles of lining a tattoo.

If you ride the tube it means that you have the needle set to protrude a certain distance from the tip of the tube. You then rest the tip of the tube against the skin and you can never go to deep into the skin and cause scarring. The drawback being that you can't see the lines of the stencil quite as well as the tip of the tube will be obscuring your view and you have to learn to judge it.

Riding the needle is how I tattooed and how a lot of the top tattooists in the world also tattoo. This refers to having the needle set to hang out of the tube too far on purpose so that you can tattoo with more precision. This is a hard technique to learn due to the high likelihood of pressing to hard and therefore going too deep and scarring your client.

The reason I mention this is because when you have the needle set to hang out too far you also need it to go right back up inside the tube when the machine isn't running. This requires a long throw on the machine so it will influence greatly the type of liner you buy.

The only way to find out your personal preference is to try it and see what suits you best. I actually used a shading machine for my line work due to it having such a long throw.

5 DOES AGE MATTER?

I have been asked this question a surprising amount of times over the years, mainly by people over 30 who are only just entertaining the idea of making tattooing their career.

My response to this question is always the same, age does not matter at all. As long as you aren't 80 and shaking like a leaf with the finger dexterity of a turnip, you will be fine.

As far as being too young goes, at the time of writing this book, there is no laws regarding how old you have to be to tattoo another person. This is why you can find videos of tattooists letting their kids have their first try at tattooing at a very young age.

Having said that a lot of studios will not want anyone under the age of 18 in the shop on a regular basis as it is an age restricted industry in general. I personally wouldn't have taken on an apprentice under 18 unless they were exceptionally talented and not too far off their 18th birthday.

If you are under 18 and want to get started however I always recommend getting your foot in the door. You can call shops in advance, tell them your age and say that you are interested in starting tattooing although you understand that many shops wouldn't take an apprentice under the age of 18 so you wanted to call first. If you get a good response then you can ask them if it would be ok to take some of your work down for them to take a

look at and get their advice on how to improve.

Doing this will make you seem more diligent and enthusiastic than a lot of other people asking them for apprenticeships, and trust me there will be a lot, but also it will help you get on good terms with the staff at the shops in your areas.

What I would then recommend is to take their advice, go away and work on your portfolio and improving on the things they suggested. Once you have done this go back and talk to them again and show them the new work. They will most likely give you more tips and send you on your way again but this will build up a rapport. Even doing little things like dropping in a Christmas card to say thank you for helping you with your portfolio will help a lot to set you apart from all the other potential apprentices.

Being in their good books will not only help your chances of getting an apprenticeship in their shop, but when other tattooists they know are looking for an apprentice they may also put your name forward.

The other benefit of this is that you will get to know what the shops are like and who you would prefer to learn from when the time comes.

6 SELF TAUGHT TATTOOISTS

I thought I had better quickly cover this in the book seeing as a lot of people get disheartened by being constantly knocked back by shops while trying to get their apprenticeship.

In my eyes the only safe and surefire way to learn tattooing is in a licensed shop with an experienced professional mentor. This will ensure at least that the standard council enforced health and safety regulations are being met.

You have to remember this is an industry dealing with sharps, dirty needles, bodily fluids and hazardous waste. The importance of proper health and safety cannot be overstated.

When learning at home from tattooists that are stupid enough to try and make a quick buck out of posting tutorials online for everyone to see, you will not learn properly and you will not learn safely. You will not only be putting yourself at risk but your clients too.

There are so many things that self-taught tattooists will not think of with regards to cross contamination between clients that even if they think they have all the bases covered they won't. I have met self-taught tattooists, or as we call them in the industry "scratchers", who think they are safe and clean and been able to point out a multitude of dangerous practices within minutes.

Of course they protest their innocence and maintain that they are safe and clean and that apprenticeships are a waste of time. I can tell you from experience they are not. The rules are there to keep us safe and need to be followed.

Scratchers are not to be confused with home tattooists however. Home tattooists are just as safe and clean as any shop generally. A scratcher is someone who is tattooing without a license, a home tattooist is licensed to tattoo at home.

I will go into how licensing works in more detail later in the book in the "Getting Registered" chapter.

7 PAID APPRENTICESHIPS

By paid apprenticeships I suppose I mean two things. One would be getting paid for doing your apprenticeship and the other would be paying someone to teach you. I will cover the latter first as it's much more common.

In recent times there has been an abundance of tattoo schools cropping up claiming they can teach you to tattoo properly and safely in a matter of weeks. Well, they can't. Especially because these courses are generally group sessions where you will not get the personal, one on one guidance that you need. This is not what I mean by a paid apprenticeship however.

The newest trend seems to be for tattooists to offer a full traditional style apprenticeship for around the £2000 mark generally. I would be extremely wary of these deals though for a number of reasons.

The main thing you can safely assume about the tattooists offering to train you in return for money is that they don't actually care about the person they are training. I say this because if they actually gave a damn about choosing the right person for the job they would do just that, not choose the person who has the most money. Surely the person who you want to train you in the job that you will be doing for the foreseeable future to want to train you due to your artistic ability, attitude and desire to learn. Not just because you have a spare couple of grand enabling you to take the fast track.

HOW TO LEARN TATTOOING

Another thing that you should consider is why do these tattooists need to subsidize their earnings from training other people for money? Can they not earn enough from tattooing? There is probably a reason for this. That reason is probably because they're, well…crap. If the person who is training you can't tattoo very well themselves then obviously they aren't going to be able to train you to a decent standard.

The last assumption I can draw is that the tattooists that will charge you are simply in it for the money. No tattooist who is passionate about their work and strives for the best will choose an apprentice based on anything other than artistic ability.

I know first-hand how frustrating learning from a tattooists who is mainly motivated by money can be. The guy who trained me didn't like tattooing. He thought, like many other people, that it was just an easy way of earning money quickly. When he found out it wasn't, it was too late. He had already set up his shop and put a lot of money into it and couldn't back out now. So his solution was to get me in and train me quickly as possible so that I could take over all of his clients. He called me tattooing full time and taking all his client off his hands "training" so that he could still keep all the money.

Situations where apprentices are exploited by disenchanted tattooists are commonplace in the modern industry. So obviously a tattooist who is charging you to train with them are far more likely to be of a similar ilk to these money grabbers with no passion for the job.

So now to getting paid while you are training. Unfortunately for you, this is pretty much unheard of. It does happen, but hardly ever. But let's be honest, if you expect someone to let you soak up their knowledge and become potential competition for them in the long run and then pay you for the privilege then you're having a bit of a laugh.

8 EARNING MONEY WHILST DOING YOUR APPRENTICESHIP

This is something I get asked about a lot. Obviously you're getting into a time consuming un-paid apprenticeship, so how do you survive?

Well there's a few options and it depends on your current living situation and a few other things. Obviously if you're living at home and have nice parents who will let you sponge for a while longer then you're sorted. If you need to pay rent, bills and buy your own food then it gets a bit more complicated.

Most apprenticeships and 5-6 days a week so the best solution is to get an evening job or a job on the weekends. This will leave you with no social life and completely knackered out of course but there's not much you can do about that.

But if you fancy getting a bit more creative with your talents and trying some different ways of earning passive income then I may have a few handy tips for you. Passive income is something I'm extremely interested in with my youtube exploits and even this book is a source of passive income. If you're reading this right now then either a friend gave it you, you illegally downloaded it or you bought it. If you bought it then you contributed to my passive income, thanks!

HOW TO LEARN TATTOOING

A source of passive income is something you will need to start way in advance, it's not an overnight thing and takes a long time to see any real results. However, once established it's a solid lump sum of cash paid into your account automatically every month. As someone who is artistically talented you therefore have a unique skillset that you can use to your advantage in this respect.

So option number one and probably the easiest option is to set up a youtube channel and put up videos about drawing, how to draw, how your apprenticeship is going etc. For this you pretty much just need a phone seeing as they are pretty much all HD these days anyway and you can upload straight to youtube from your phone too. Easy!

Another good way of earning passive income is to sell prints of your tattoo flash. "That's not passive income" I hear you cry. Well actually it can be. In the wonderful modern age that we live in you don't have to hold stock, process orders, go down the post office three times a week etc. There are websites out there that do all that for you. All you have to do is scan your flash and send it to them. They do the rest! Of course they take a big cut of the money paid for the prints but that is to be expected and it's pretty much free money for you seeing as you're painting the stuff up anyway.

To find the websites that do this just search on google for something like "tattoo flash for sale" and get in touch with them with some examples of your work to see if they are interested in stocking your flash. If you don't get a reply then just improve and try again. I got a reply from gentlemanstattooflash.com expressing their interest in stocking my work but I never ended up finishing the set that I was working on as I quit tattooing.

There is also a few other random jobs you can do such as sign writing for restaurants and pubs etc. I know a couple of people who have made some easy money writing fancy script on a chalk board for local businesses. So basically my advice would be use your creativity to avoid having to get a job on top of your apprenticeship if possible.

9 CREATING A PORTFOLIO

Well this is probably the chapter you have all been waiting for. Having a strong portfolio is the biggest factor in whether you get offered an apprenticeship or not.

So let's start this portfolio off right, get yourself a decent folder. No one want's to sift through a bunch of random bits of paper when looking at your work even if it is really good. They want it nicely presented so they can turn the pages and browse with ease. This goes for both tattooists that are considering you as a potential apprentice, clients that are considering getting tattooed by you and shop owners that are considering employing you to work in their shop. That's a lot of considering right there, all that considering is made all the easier by a nice folder trust me.

Remember, your portfolio is all about standing out from the crowd and I had so many people come to me with badly presented work. It did my head in! I don't understand how people can put so much time and effort into drawing, painting and learning about composition and colour theory only to throw their work into a A2 plastic carry case and slap it down on my desk.

So you have your nice folder, I'm impressed this looks very professional! Let's open that bad boy up, oh just some random bit of flash sitting there? No! Paint up a nice cover page saying "Tattoo Flash Portfolio" and your name in some fancy script or something. Get creative with it. This adds massive professionalism and brownie points in my book and it's as simple

as doing a bit of script and maybe adding some cool looking illustration on there.

So once you have that done, now it's time for the bit we have all been waiting for. When I flip over to that next page after all this professional awesomeness I don't want to see pencil drawings or line illustrations. I don't want to see some cross hatching you did with a biro. I don't want to see a print out of a landscape painting you did once. I don't care how smooth you can shade a study of an ear using a HB pencil. What I want to see is tattoo flash.

Now let me clarify what I mean by tattoo flash. Flash is the stuff you see on the walls and in books or folders in tattoo studios. Properly painted sheets, nicely presented. None of this ripped out bit of paper stuck onto another sheet with PVA.

Do your flash on decent quality paper, line using the proper tools, shade and colour using paints or inks. Don't use printer paper with pencil line work and then slap some watercolour on it, it will look like crap!

I only ever use 300gsm cold pressed water colour paper for my tattoo flash work. I line using either a brush and ink or a technical drawing pen like a Zig Millennium or a Uni Pin. I shade and colour using inks, either from markers or using a paint brush. It's really up to personal preference but just don't use colouring pencils or water colours because they just look amateur.

The reason I say to use inks is because they work much the same as tattooing does in that they are permanent. Watercolour however will come off when it gets wet so you can lay down your black shading and then when you go to paint over it with the colour it will rub off the black underneath. Obviously this doesn't happen in tattooing so you don't want it happening in your tattoo flash work either.

If you're not great at painting with inks then no worries, just use markers like Copic brush tips. I have a youtube channel where I have posted a bunch of videos about using Copic Markers with a whole bunch of other information on painting tattoo flash. If you're interested you can take a look at www.youtube.com/gdgtv

10 STYLES OF ARTWORK

Now that you have a nicely presented portfolio and well painted flash. What do you paint and where do you put what and in what order?

You may or may not have an idea of the style you are most interested in at this point. For me, when I started my apprenticeship, I loved neo-traditional. If you're unfamiliar with this term, neo-traditional is a style based on the old school imagery such as ships, anchors, snakes, daggers, tiger heads etc. but made a lot more detailed, colorful and modern. It's really a natural progression, the roots of tattooing being carried into the modern age. So I based my portfolio on this style and painted all of my flash in the neo-traditional way, albeit rather poorly at first.

I ended up getting sick of neo-traditional due to it becoming extremely popular and having to tattoo it 90% of the time. Only then realizing it was just some craze that everyone was jumping onto. But I was now stuck with it seeing as it was what I had done for my whole career.

I ended up covering my section of the walls in the shop with bare bones traditional 50's style flash as that's what I found I really had a passion for but it was hard to make the transition and people kept asking me for neo-traditional regardless. So consider carefully what you want to get into when deciding if you want to base your portfolio around a single style as this can have repercussions down the line.

Another more pressing issue with having a limited style of work in your portfolio is that it cuts down the chance of getting an apprenticeship. For example if you did do a neo-traditional portfolio and took it into 10 shops, only one of the tattooists may find merit in your work due to the others being interested in different styles. Or even worse, none of the shops in your area do that style. So it may help to diversify at first.

As I mentioned earlier in the book you should also consider that shop owners will want an apprentice that can comfortably cover a range of styles so that you can earn them the most money possible. The owner may have nothing to do with you getting the spot seeing as the tattooists will be the ones training you and will probably have the final say. Having said that, in some shops the owners are more closely involved than others and will want to meet you and see your work first so it's worth bearing in mind.

Having a range of styles in your portfolio doesn't mean you have to be a jack of all trades for your entire career however. It will help you to start off with when you have no choice in what you will be tattooing. Then once you are established and making a name for yourself as a professional tattooist and building up a client base you can start turning away work that isn't the style you want to do. In this way you can become a specialist in your chosen field, although this is hard to do and you will probably be tattooing anything you can for a few years to pay the bills and gain experience.

When organizing your portfolio it is best to break it up into sections for the different styles. This will just make it easier for anyone flicking through to gauge your ability at the different styles and make for a better browsing experience.

11 CREATING A SKETCHBOOK

Sketchbooks should not be used as a standalone portfolio but can be a fantastic addition to your portfolio. I think a sketchbook is pretty much a must if you really want to make the best impression possible.

The reason I'm such a big fan of sketchbooks is because it shows your process and your raw unedited sketching ability without all the frills and finishing touches. This is particularly effective when you sketch up designs that you will then use in your flash for your portfolio. This shows the progression from initial sketch to finished drawing which is great because a lot of people now just copy other peoples flash and paint it as their own. However if you have a supporting sketchbook with your process shown there is proof that you have actually drawn it yourself.

My main tip for an effective sketchbook is to just be loose and have fun with it, sketch out ideas for flash and designs. If you see a tattoo or a piece of artwork you like, rather than trying to paint it straight up into a sheet, sketch out your own version in your sketch book. Add and remove elements, play with the composition etc.

Building up layers is a great way of working and showing you process on one page. So start with a light colour pencil like a yellow and rough in the elements of the design, go in and neaten up with a red pencil then go over with black and tighten it up. Use cross hatching or scribble to test where you want to put the shading. You can even tape a piece of tracing paper

over a page and go over in pen so that the tattooist can lift it up and see the sketch underneath that you started with.

Also, add notes. Jot down what you like and what you don't like. For me little notes on the page shows personality and it helps the tattooist to know what you thought of the sketch at the time of drawing it. You could write what you need to improve, what you like about it and ideas for the colour theory or even just scribble it out and write "This is crap" next to it! Just have fun with it and don't over think it. It's not your main portfolio so don't worry about it.

12 FINDING AN APPRENTICESHIP

So you have a well painted, nicely presented portfolio and a supporting sketchbook to show your process. Finally, after all that hard work and dedication, it's time to get rejected countless times and be told your work isn't good enough. I wish I was joking!

Unless you are ridiculously naturally talented then you're going to get knocked back, a lot. So be prepared. This could be for a lot of reasons. You may genuinely be really bad, you may catch a tattooist on a bad day or you may just be seen as competition. If there's one thing tattooists hate it's someone that is better than them that could potentially take their clients away and cause them to lose money. So don't get disheartened by the rejection, it happens to us all at first.

Or even worse, you may get a tattooist that is really bad and they think that just because they know how to use a tattoo machine, this automatically makes them a better artist than you. Some of these particularly poor tattooists may give you advice on your artwork when they can't even draw as well as you can.

Unfortunately you're going to have to just shut up and deal with it because if you start answering them back, even if you don't want to work in their shop after meeting them they may know other tattooists in the area and you don't want them spreading bad rumors about you. It could in fact work in your favor if you're polite and kiss their butt a bit. They may know

someone looking for an apprentice and if you make them like you they might just give you a new contact. So pucker up and get ready to lay a nice wet one on those bum cheeks.

It's always best to hedge your bets and get talking to as many shops as possible when looking for an apprenticeship as they are extremely hard to come by. However I would do your research first and apply to the ones you would prefer to work in first. A bit like having a first choice for what uni you want to go to and having the others as backups. Obviously don't tell them that.

I say this because if you go in head first and apply to them all at once then the less busy shops are probably going to be able to see you first. You don't want to accept one of them, to then get offered a better one and have to quit only to then lose the better one after a week and wish you had stayed the not so good one.

So make a list in order of your preferences and get cracking. Now I'm in two minds over whether you should call first or just head down there, portfolio in hand and hope for the best.

Calling round is probably more sensible but far less fruitful. We had countless people call the shop to just be rejected where as if someone came in with their portfolio we would have felt a bit bad turning them away at the door and would probably have taken the time to go through their portfolio with them.

I guess this one is up to personal preference as calling in advance is more polite and you will be able to make an appointment to see them. You could always call and then go down a couple of weeks later anyway if they tell you they aren't looking.

If they do tell you they aren't looking for an apprentice at that time and to call back in 6 months or whatever, don't do that, very bad idea. You need to get your foot in the door before all the other people that are trying to get in there. Also they may lose their apprentice within the next couple of months and when you call back 6 months later you will have lost your window of opportunity.

The best thing you can do is say that as they aren't looking for an apprentice could you bring your portfolio down to the shop and get some pointers on your flash as you really like the work of the tattooists there. Giving them a nice compliment and making them feel like you value their

opinion should seal the deal nicely. This way you can head down there, meet them, make a good impression, show them your work and you will then stick in their head.

Don't leave it there though, go back a month later and see them again. Show them that you have taken their advice on board and show them how you have improved based on their amazing advice and thank them, a lot. Tell them you saw the tattoo they posted on facebook the other day and how good it was, maybe even tell them specifically what you liked about it in some weird arty way so that they think you know what you're talking about. Repeat this process with a few shops and you will be head and shoulders above the competition. Then when you get offered an apprenticeship send me £200 to show your appreciation for this ridiculously good advice!

13 CHOOSING THE RIGHT SHOP TO LEARN IN

Now choosing the right shop for you is a lot more complicated than it sounds. It's not just a case of, well I prefer this person's work so I will apply to them.

You should consider obviously the quality of the tattooing, the style of tattooing, the cleanliness of the shop, how busy they are and their attitude. The quality goes without saying, you don't want to learn how to tattoo from someone putting out shaky line work and patchy shading. They will simply teach you bad habits. When looking at their work really study the smoothness and quality of the lines. Shading and colouring can really mask bad line work so look carefully! You also want to look at the shading and see if it's smooth and if it blends nicely. The colouring should be smooth too without any patches.

Not only should you be looking at the quality of the tattooing but the composition, the placement, how the tattoos flow with the contours of the clients body, the colour theory etc. You will be surprised how many people can look at a bad tattoo and think it's good until I point out everything that is wrong with it so really take a good hard look at their work. It's best to pick well because remember this is the person who will be showing you everything you know.

Now cleanliness, this is hard to spot for an amateur but while you're in

there and they are going through your portfolio try and stop crapping your pants for a couple of minutes so you can look about the shop. Some shops are pretty obviously dirty but a lot of the contamination from tattooing is invisible.

One thing to look at is the tattooist's stations. Have they cling filmed the surfaces such as the worktop and the chair or armrest they are tattooing on? Are their clip chords bagged (the cable that connects the machine to the power supply)? Do they touch things with their dirty gloves on? Touching things about the shop with dirty gloves on is the number one way of cross contaminating between clients, if they are doing that then get out of there asap!

Also ask to use the toilet while you are there. The toilet is a good way of judging the overall cleanliness of a shop. Obviously sometimes a grubby client might wee on the seat or leave a nice floater sitting in the bowl, don't worry about that. But look at the floor and the generally cleanliness of the toilet. If they don't take pride in their facilities then they probably aren't that bothered about the cleanliness of the shop. This actually works trust me!

How busy the shop is can give you an idea of the quality of the tattooists but it could just mean that the shop is in a busy location. The main reason why I say that you should look for a busy shop is because you will learn much quicker. In a slow shop you may be sat about for extended periods of time doing nothing. In a busy shop you will constantly be watching tattooing being carried out and dealing with clients, just generally soaking up information at a faster rate. Also most apprentices end up working at the shop they trained in so being in a busy location means there will be a lot of work for you to share with the other tattooists to get you started.

Finally you really do need to try and judge the personality of the tattooists or tattooist that will be training you. Actually even if they're not training you, you may be one tattooist's personal apprentice but one of the other tattooists there might be a massive tool. Obviously you may not be able to be super picky about where you learn so just judge their characters and try not to get on anyone's nerves.

14 YOUR FIRST DAY ON THE JOB

By on the job I don't mean prostitution. I am in fact referring to the even more daunting task of showing up on your first day of your new apprenticeship. Actually it's probably far less daunting than prostitution to be fair, so let that be of some comfort to you while you're about to walk in on your first day. At least you're not having sex with a strange man for money.

So when you walk in you will most likely be instantly directed to the nearest kettle to carry out your most important duty as an apprentice, being the shops resident hot beverage maker. Sometimes also referred to as tea monkey or tea bitch.

I doubt you will be shown too much on the first day, they will probably give you a tour of the shop. You will probably be introduced to the autoclave and the ultrasonic cleaner. You will be mostly watching and learning for a while although they may want to get you started on setting up and breaking down their station for them as soon as possible. I will go over all this stuff in more detail in the next chapter.

Remember to try and show interest in everything, pretend that you're a little knowledge sponge and you're soaking in all the information. Ask lots of questions but not to an annoying extent. Don't just sit there like a mouse and be awkward, talk to the clients and put them at ease. I loved it when my clients and my apprentices would have a chat while I was tattooing. It

meant that I didn't have to pretend to be interested in what they were saying and make mundane conversation about current affairs or the weather.

Basically my main pieces of advice to you on your first day is to remember everyone's names, remember how many sugars they have and try to not annoy anyone and you will be fine.

15 WHAT ARE A TATTOO APPRENTICES DUTIES?

Basically you're the shop bitch. Everything that everyone else doesn't want to do is what you will be doing. Mainly cleaning, everything from mopping the floor to sterilizing the tubes.

The ultrasonic cleaner will become your worst enemy. This is where the tubes go to have all the ink and dry blood cleaned off of them. It's generally a small metal box containing liquid and a cage. The tubes go in the cage and are dunked into the liquid which is water mixed with an ultrasonic cleaning powder. The cleaner then get switched on vibrates faster than a mosquito on speed, creating lots of tiny bubbles that clean away any residue left on the tubes. You will be loading this and emptying and refilling it countless times. Not only this, you will also need to scrub the tubes with those little wire pipe cleaners so good luck with that. Remember though ALWAYS USE GLOVES. I can't stress this enough. The ultrasonic has loads of blood borne pathogens floating round in it so don't touch anything with bare hands.

The cleaned tubes then need to be sterilized in the autoclave. So you will be taking the tubes out and drying them off, then bagging them up, then putting them in the autoclave. Then running the autoclave and emptying it and putting the tubes back so they can be made dirty and you have to clean them all over again. Sounds like fun doesn't it?

If you're wondering what an autoclave is, it's basically an overpowered pressure cooker. It fills with steam which obviously is boiling because water needs to boil to create steam so it's pretty damn hot. But then it pressurizes the steam which brings it to an even higher temperature. This kills anything viruses etc. that may be lurking on the tubes.

Probably the most annoying thing you will have to do is set up and break down the tattooists stations. This refers to the process of cling filming the worktop or trolley surface that the tattooist will be working on. You will also need to put out their Vaseline, ink caps, machines, tubes, needles, paper towels, razor, rinse bottle and probably cups of water for rinsing the tube between colours. You will also need to bag the clip chord and rinse bottle and cling film any area of the chair, table or arm rest that may become contaminated during the tattoo.

Then after the tattoo is completed you will have to break all of this down. By which I mean you will need to throw all of the cling film away and any leftover paper towels etc. You then need to un-bag the bagged stuff and throw that away. Put the head of the razor and the used needles in the sharps bin and then wipe everything down with surface disinfectant.

You will also have to wipe down the shelves and ink bottles, clean the surfaces with a high level surface disinfectant and mop the floor. This really is bitch work but there is method to the madness. All this repetitive cleaning gets the process ingrained into your head so well that it becomes second nature. This is important as the processes need to be followed to the letter so that there is no chance of cross contamination between clients. Also you can be fairly sure you have a safe and clean working environment.

The other reason for the bitch work is to separate those who just fancy giving tattooing a go from the people who are willing to put up with all this crap because they genuinely want to make tattooing their career. If you stick it out then you are deemed to have "paid your dues" and you will get a career at the end of it. It's not actually a bad system at all when you think about it like that.

There will be days during your apprenticeship that you will simply think "sod this".

16 HOW LONG WILL IT TAKE TO START TATTOOING?

This is a very hard question to answer as it completely depends on who is training you. The general length of a tattoo apprenticeship is about 2 years. Of course you will be tattooing before then to get practice.

You will most probably start by tattooing fruit, fake skin or pig skin. I personally don't rate fruit as a good way of practicing. Fake skin is also not great usually although I haven't tried it in years so it might have got better by now. Pig skin is pretty cheap and half decent, you can get it from most butchers. Sometimes they will just give it to you for free as they don't really use it.

Pig skin is probably the most commonly used practice material but it does have its drawbacks. It's very greasy so doesn't take a stencil well, although you can give it a good clean with green soap and alcohol and this does help. It's also very hard to wipe clean, the ink seems to stick to it and not wipe off. Having said that, it's probably the closest thing to human skin you will get.

So you probably won't tattoo a person for about a year in most apprenticeships. As I say, this can vary. Some shops will want to rush you though and get you started as soon as possible and some shops may want to hold you back as much as possible. Both of these are bad for various

reasons.

If your training is rushed you won't have enough time to gain the knowledge needed to cover the various eventualities that can occur during a tattoo. This can lead to more mistakes being made and this will harm your confidence and cause you to actually progress slower than if you weren't even tattooing yet. So don't be in too much of a rush to tattoo a person, get your confidence up on the pig skin first and watch your mentor intently as they tattoo.

Being held back is obviously detrimental to your learning and is fairly common. Some tattooists will want you to keep doing all their cleaning for them forever. Some may feel like you have gotten to the stage where they feel threatened by you. Whatever the reason, this can be very frustrating as there really isn't anything you can do about it seeing as they have the say so on when you tattoo. All you can try is keep pestering them about feel ready and tell them that you have friends that have seen your work and want to get tattooed etc.

17 WHEN WILL YOU START MAKING MONEY

When you are finally allowed to tattoo clients you will have to do it for free because you will just be essentially practicing on them. Not really fair to charge someone to be your lab rat, plus most people would probably tell you to jog on.

Having said that, I actually earned £20 from my first ever tattoo in my apprenticeship via the tattooists best friend, the tip. In general if you do a good job on a tattoo and the client doesn't feel that you have overcharged you should really get a tip. So seeing as you aren't charging these guys anything, if you do a good job, they would have to be a pretty tight bastard to not chuck you a tenner. Best thing about tips is that they are all yours, whack it in your pocket tax free and without giving half to the shop.

So your first money will almost certainly be tips and you will start getting them pretty much as soon as you start tattooing anyone, this should be a year or so into your apprenticeship. Then gradually over the next year or so you will improve and you will be able to start setting a low hourly rate and putting it up bit by bit. I would say after a year's tattooing your apprenticeship will be over and you will be experienced enough to charge full whack.

So 2 years in total. I don't think that's too bad considering that after a year you start earning a bit whilst learning. If you can get through the first year on no money then you will have a career for the rest of your life. Students

go to college and uni spending thousands and getting themselves into debts they won't clear for years just to do a degree that they will never use for the rest of their life just because society expects it of them. So compared to them, you're going to have it pretty sweet.

18 IS TATTOOING HARD TO LEARN?

This completely depends on who is training you and how smart you are. If you're an idiot who can't watch and take things in while your mentor is tattooing and get a really good idea of the technique before you even pick up a machine then you will find it very hard.

I think this is the main factor in learning to tattoo to a good standard quickly. Just watch the wrist movements, watch if they move their whole arm or just use the wrist, notice how they stretch the skin etc. If you really study every detail you will find it much easier when you pick up a machine for the first time.

Obviously, as I said, it also depends on how good of a teacher you have. A good tattooist doesn't necessarily mean they will make a good teacher. Although it does help a lot, they might not be able to communicate things in a way you understand very well for example. Or they just might not give a crap about helping you to learn properly.

A good mentor will put you at ease and make you feel relaxed but also watch you to make sure you're doing everything right. I personally wouldn't hang over my apprentices shoulder, I would give them some pig skin and let them crack on whilst keeping an eye on them on the sly so they didn't feel pressured. Then if I saw them doing something wrong I would go and interrupt.

Then when my apprentice was tattooing pig skin to a good enough standard I would let them tattoo someone they knew. It's good to tattoo a close friend for your first client because you will be nervous enough as it is. I just let them get on with it, basically just said I was there if they needed anything or if they made a mistake not to worry and I would jump in and fix it quickly.

Not everyone teaches like this unfortunately and they will want to be hovering over you while you're tattooing. If they do this and it's putting you off mention it before your client comes in and hopefully they will respect that and give you some breathing room to concentrate.

A lot of it is about confidence. Not just when you're starting out but over your whole career. You need to get into the mindset that you're going to knock it out of the park and when everyone sees how good your first tattoo is they will be blown away. If you go into it worrying and thinking how bad it could turn out then it probably will be pretty bad. So believe in yourself, trick yourself into thinking you're the don. Really sell it and act super professional, play the part of the experienced tattooist and you will be 10 times better instantly.

Overall I think the apprenticeship process is long and hard (that's what she said). Learning to tattoo as in practicing on pig skin and moving onto clients isn't really that bad at all. Tattooing people is so much easier than tattooing pig skin so if you can do it in practice then putting it into action shouldn't be too much of a problem.

19 GETTING REGISTERED

I can only speak for the two councils I have been registered in, both in the UK. Abroad it may be slightly different but I image they would all work in much the same way.

There is a lot of confusion about tattooists getting registered so let me clear this up for you. Strictly speaking there is no such thing as a registered tattooist. You get licensed to tattoo in a shop, so it's really the shop that is getting inspected and you're being licensed to work there. This doesn't mean you can just move to another shop and still be tattooing legally. You have to get registered for every place you work at. So although you will have a bit of paper with your name on it, it won't say that you are a licensed tattooist, it will say that you are registered to carry out your work at the shop.

The first time I got registered was in a sleepy countryside town with no other tattooists so the council visited me 3 times with 2 different inspectors and asked me all the questions under the sun before they would give me my license. I think they just didn't want their scenic little town invaded by big scary bikers covered in tattoos so they were very strict with me and really didn't want me there. When they couldn't find any legal reason not to register me then finally gave in but it was months before I was allowed to legally tattoo there.

The second time, it was a brand new shop in a much bigger much more

popular town. This time working for someone else because I didn't want to own my own shop anymore, it was way too much hassle. So there I was ready for all his questions, he walks in and takes a quick glimpse about the shop and says "Ok you look like you know what you're doing, here's your licenses". I was shocked by this seeing as this guy was registering all the shops in the area, this means he was enforcing the health and safety of about 50 shops at the time, probably more by now. He couldn't have cared less.

So the difficulty of getting registered really does depend on where you are and who you get. Each council will be able to provide you with an information pack on tattooing telling you what they expect of you and it's a very good idea to read this as its pretty much a standardized set of rules and regulations that you have to follow. You need to know the entire contents of that pack even if they don't ask you any questions on it purely for the safety of you and your clients. You can get hold of one for free by simply asking your local council so no excuses.

As long as you have read the information and the shop you are working in has all the necessary facilities such as sharps disposal, clinical waste disposal, hot and cold running water etc. then you should have no problems at all getting registered.

20 FINAL THROUGHTS

Well, that's about all you need to know to get started in the world of tattooing! I'm pretty sure I have covered all the questions that I regularly get asked on my youtube channel in enough detail to give you a big advantage over the competition.

Tattooing definitely isn't for everyone and it wasn't for me. Took me a while to realize it in the end but some people take to it like a pig to mud. You wont really know until you try it but remember what I said in the first couple of chapters about how you won't earn as much as you think and all the warnings about things that may annoy you.

Hopefully I didn't ramble too much I wanted to keep this book fairly short so that the main points would stick in your head more easily. No point in bombarding you with irrelevant information, although I'm sure I could have bearing in mind I can talk for England.

I really hope you enjoyed the book and have found it useful and as I mentioned earlier in the book, I have a youtube channel where I have done a far few tattoo flash drawing and painting tutorials. Pretty much all of the videos are in the old school/traditional style so if you're interested in that style of artwork I would definitely recommend taking a look. Not to brag but at the time of writing this book I have almost 20,000 subscribers so it's not a bad channel honestly!

You can take a look at – www.youtube.com/gdgtv

Keep your eyes peeled for more books coming in the future. If I get enough good reviews on this book and enough sales I may well make another about a different aspect of my experience within the tattooing world.

That's a good point actually, if you did enjoy this book please don't forget to leave me a review! It helps so much with getting more sales, not if you leave a 3 or 4 star review though that kind of puts people off, 5 star all the way! I would really appreciate you taking the time to do it so thanks in advance if you do.

Other than that, thanks for buying and reading the book and hopefully I will be seeing your work in a magazine somewhere soon!

www.ingramcontent.com/pod-product-compliance
Lightning Source LLC
Chambersburg PA
CBHW071825170526
45167CB00003B/1429